D1537525

 A Year of Iowa Nature

A Bur Oak Book | Holly Carver, series editor

ELY PUBLIC LIBRARY
P.O. Box 249
1595 Dows St.
Ely, IA 52227

A Year of Iowa Nature

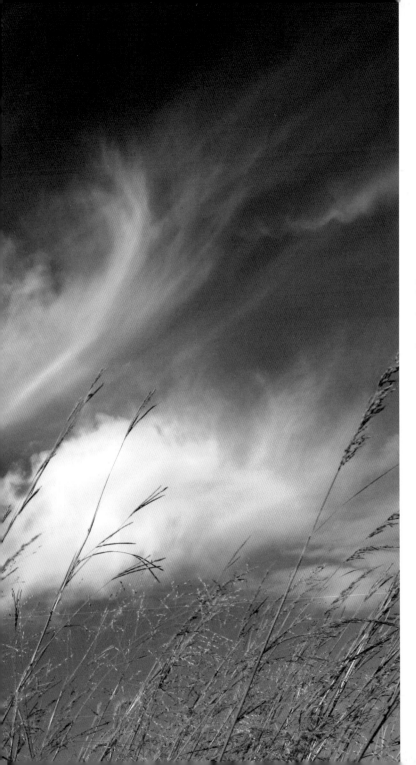

Discovering

Where

We Live

CARL KURTZ

University of Iowa Press
Iowa City

University of Iowa Press, Iowa City 52242
Copyright © 2014 by the University of Iowa Press
www.uiowapress.org
Printed in the United States of America

Design by Kristina Kachele Design, llc

No part of this book may be reproduced or used in any form or by any means without permission in writing from the publisher. All reasonable steps have been taken to contact copyright holders of material used in this book. The publisher would be pleased to make suitable arrangements with any whom it has not been possible to reach.

The University of Iowa Press is a member of Green Press Initiative and is committed to preserving natural resources.

Printed on acid-free paper

Library of Congress Cataloging-in-Publication Data
Kurtz, Carl.
A year of Iowa nature: discovering where we live / by Carl Kurtz.
pages cm.—(A bur oak book)
ISBN: 978-1-60938-240-7, 1-60938-240-4 (pbk)
ISBN: 978-1-60938-252-0, 1-60938-252-8 (ebk)
1. Natural history—Iowa—Pictorial works. 2. Nature photography—Iowa. 3. Landscape photography—Iowa. I. Title.
QH105.I8K87 2014
508.777—dc23 2013037983

1046226

To Linda, my faithful weekly editor, and to all those who have responded with interest and enthusiasm

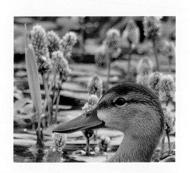

CONTENTS

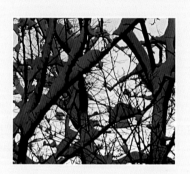

DISCOVERING WHERE WE LIVE

It is easy to overlook nature close to home unless the event is dramatic. Often our openness to nature watching only occurs on a vacation, when we confront the new and unfamiliar. One of my missions in life has been to try to help others discover nature where they live. This began in the early 1970s with photography. Most of us fail to recognize the amazing, life-sustaining world we live in.

This endeavor took a dramatic leap forward in 2004 when I purchased my first digital camera. After shooting color slide film of birds, animals, plants, weather events, and other natural history subjects for more than forty years, it was a new experience. The biggest difference in shooting with film and shooting digitally was having a usable image immediately. There was no waiting for film to be processed. After a few weeks of shooting, I felt it would be good to share current seasonal images with others and developed a list of interested friends and colleagues. I began to email them the occasional image along with a short description of its natural history. I hoped it might encourage them to observe more closely where they live. Over a matter of months, I developed a schedule of sending it out every Sunday evening.

My wife, Linda, and I live and work on an old family farm in the middle of Iowa. Before settlement in the mid-1850s, our farm was treeless, tallgrass prairie. I have always considered myself a naturalist and have a Bachelor of Science degree in fish and wildlife biology. As a youngster I hunted, fished, and roamed the area around our farm. After my college years and a short stint in the U.S. Army, I had a wonderful association with Iowa State University botanist Roger Landers, who introduced me to the tallgrass prairie in many forays throughout the state. This led to the discovery of a small remnant prairie that bordered an old railroad right-of-way that bisects our farm. Over the years I began to see that tallgrass prairie hosts a diverse wildlife community. Today some thirty-five years later, Linda and I have reestablished a major portion of our land back to tallgrass prairie. It surrounds our family home that is nestled in a small grove of trees. Opportunities to observe and experience nature occur just outside our front door day and night.

Now in 2013, some four hundred weeks have passed since this photographic adventure began. The list of weekly recipients has grown to more than four hundred individuals, and for more than five years I have kept an unbroken chain of weekly posts. This has encouraged me to keep an eye out for new or common events each week and to research their natural history. Most weekly posts are relevant to the eastern part of the United States, which not only has a great variety of natural habitats but also shares many species of plants and animals.

I have tried to select images that best represent the weeks and months throughout the year. As we watch nature through the seasons and over the years, we grow to expect specific birds, insects, and weather events with the changing seasons. They become old friends leading us to new relationships interconnected to the web of nature.

January

WHITE-TAILED DEER

Critters such as this young white-tailed deer are well prepared to deal with winter because a thick coat of underfur and lots of long guard hairs protect them from the cold. We often see them with their backs covered in snow or a thick layer of frost in early morning. It is apparent that heat loss is minimal.

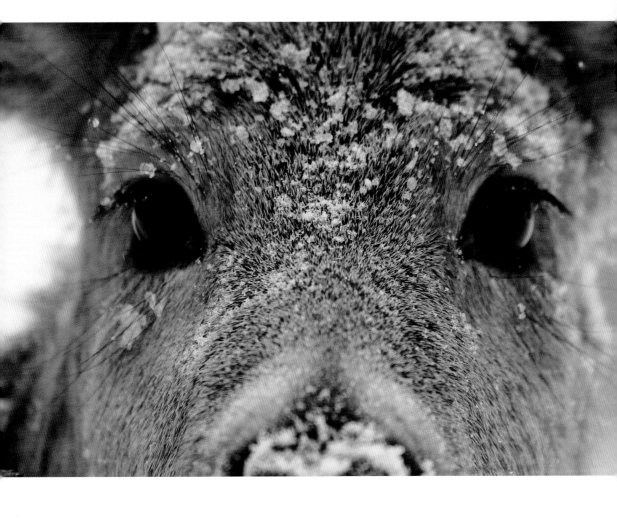

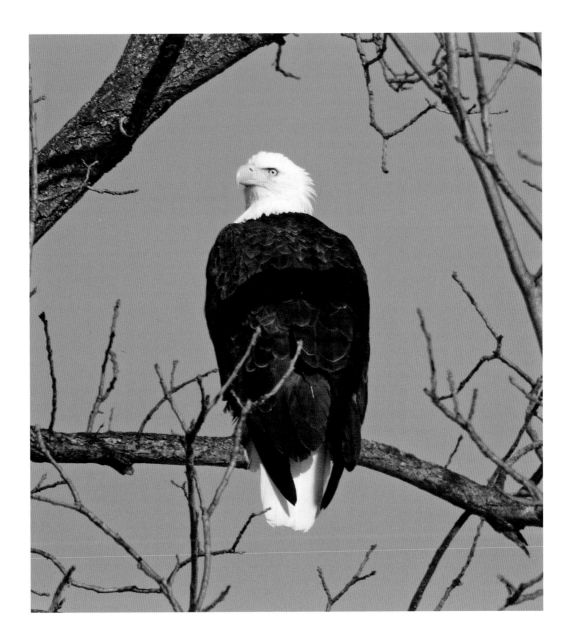

EVENING TWILIGHT

Winter is begrudgingly accepted by most of us because we have no choice; however, it reveals some basic natural concepts in their purest form. Snow picks up a blue cast (which reveals cold light) reflected from a clear blue sky overhead. It is in sharp contrast to the soft reds and yellows cast by the rays of the rising or setting sun. We can sense the coldness in the blue color and the warmth in the sun's yellow rays. Fire and ice are primordial life forces. Our habitable earth straddles a thin line between the two.

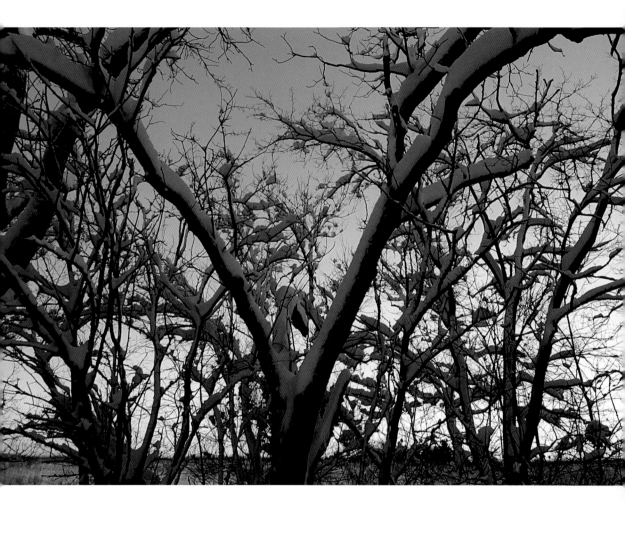

MALLARDS

If you are a mallard duck and choose to spend your winter up north where there is ice and snow, your priorities are quite simple. First and foremost, keep your feathers preened; the cold is no big deal as long as your plumage is in shape. Next, find a place with some open water; ice is no problem, but drinking and bathing are important. Finally, hang out with a group of your peers even if some of them are bigger, black and white, and called geese. The group will give you protection when napping and a flock with which to feed in the fields. And should you have a mate, sleep with one eye open. You wouldn't want her wandering off with another handsome drake.

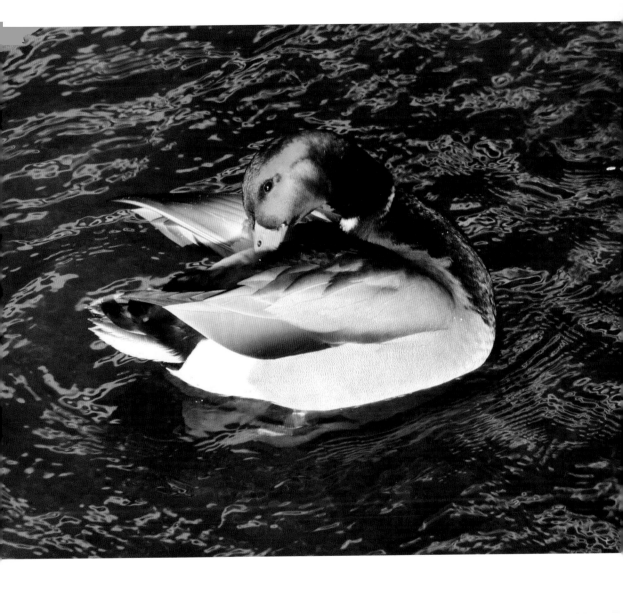

ICE DANCER

Exploring the natural world often reveals the unexpected. Ice in its formation and aging undergoes constant changes. At first it is just a thin transparent sheet, but if cold persists it gradually thickens and often turns white. Air pockets may form that reveal escaping gas from rotting vegetation. Ice also expands as it freezes, creating deep cracks and fissures. This imaginary figure seemed to be quite happy with the cold. One wonders if it, like the snowman, will still exist next week.

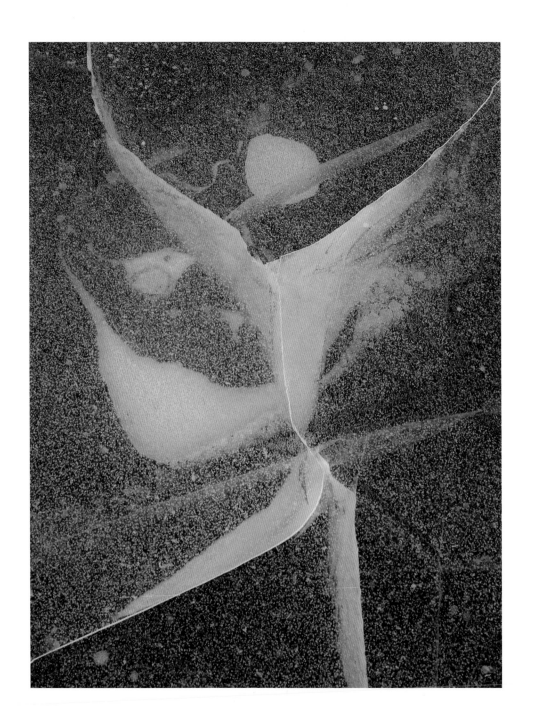

February

CARDINALS

Northern cardinals were generally uncommon in all northern states at the beginning of the last century. Habitat changes and bird feeders have likely contributed to their range expansion across the Canadian border. Everyone seems to enjoy these red finches, which readily respond to feeders filled with sunflower seeds. Cities, forested areas, and even marginal woodlands provide excellent habitat for cardinals and other winter finches.

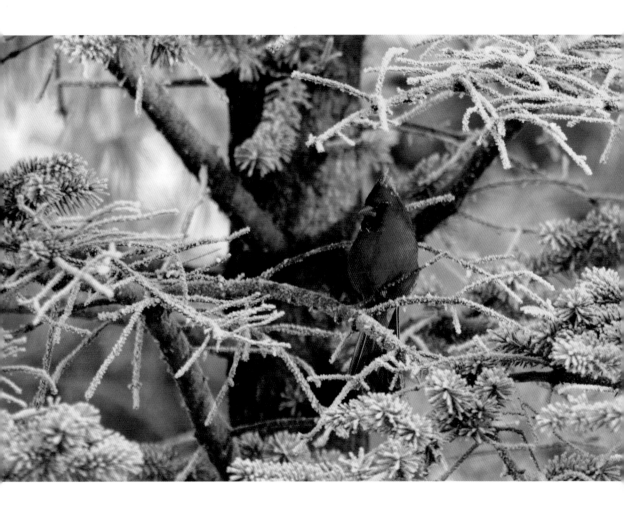

DRIFTING SNOW

Dry snowflakes are as light and soft as goose down. Add enough wind to move it around and you have a blizzard. The resulting snow is not quite the same after it has been moved and deposited leeward of a wind barrier. Unlike the soft fluffy snow that comes down, drifts can be nearly as hard as concrete. We are all familiar with snowdrifts; they come in every sort of shape and form. The surface itself can be scalloped, perfectly smooth, or deeply furrowed. Drive your car into a big deep drift and you may find it supported with the wheels off the ground. There are lots of historical records of livestock walking over fences on hard snow. Fences are often flattened or pushed over by the weight of the snow on the wires themselves. Depending on their depth or thickness, drifts, like the water of which they are composed, transmit light. Gradations of light can come through the knife-like ridges.

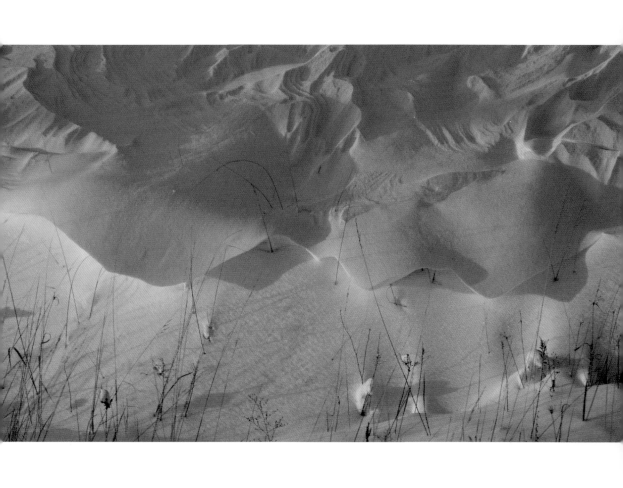

SNOW BUNTINGS

Blowing snow and freezing cold are just a daily occurrence for snow buntings and their frequent companions, horned larks and Lapland longspurs. We most often see them feeding on roadsides or in barren fields where the terrain is open and free of trees. When spring conditions begin to moderate, they head back north to nest in the tundra or on barren rocky environments, sharing habitat with Lapland longspurs. The breeding range of the horned lark overlaps the longspurs and buntings in the north but extends much farther south into farm fields of the Midwest.

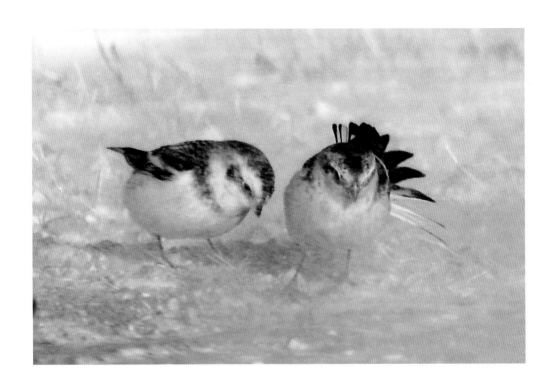

RIME ICE

Blue and green are major earth colors. Green vegetation symbolizes our productive earth, which sustains life. Blue skies indicate bright sunlight, a cloudless day with heat and light from the sun. The blue color of the sky results from the scattering of short wavelengths of light off air molecules (primarily oxygen and nitrogen) in the atmosphere. This phenomenon is called Rayleigh scattering after Lord Rayleigh, a British physicist and mathematician. There is great comfort when we look up at an intensely blue sky. Rime ice-coated trees in morning light provide a striking contrast.

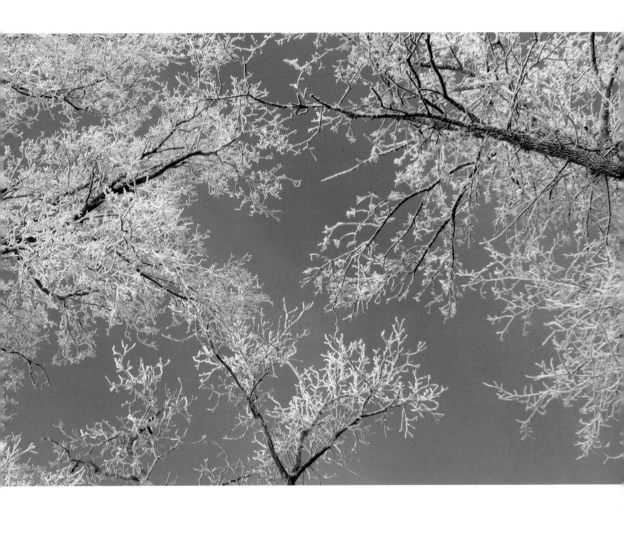

CEDAR WAXWINGS

Cedar waxwings appear as if they just came from a beauty parlor, slick and well groomed with plumage in a state of perfection. They are social in all seasons, erratically moving about in small or large groups. I have observed them eating petals of flowering apple trees in late spring, which may be a source of vitamin C. They generally are considered fruiteaters, feeding on juniper berries (from red cedars), crab apples, high bush cranberries, and a wide variety of ornamentals that produce edible fruits. In late winter they seem to relish old crab apples and apples that are rotten and fermented. There are even records of inebriated waxwings unable to fly.

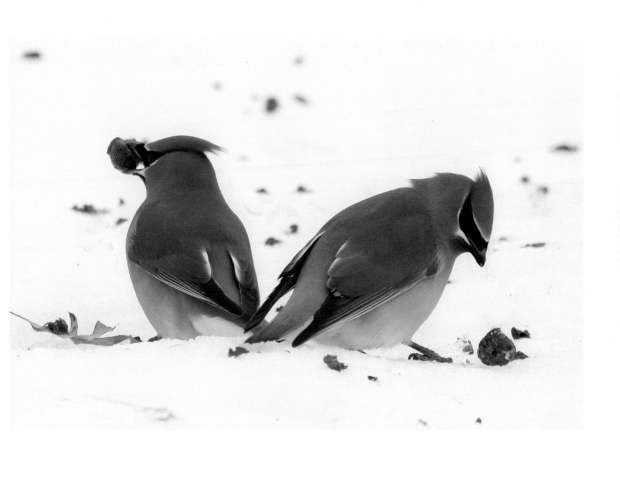

March

SNOW GEESE

Snow geese migrating north on a strong south wind seem to confirm that spring is officially under way. Their high-pitched calls attract our attention, and high overhead we see long skeins etched against the deep blue of a clear sky. Often thought of as "snows and blues," they are simply two different color phases of snow geese. In our ordered world, they are high, wild, and free.

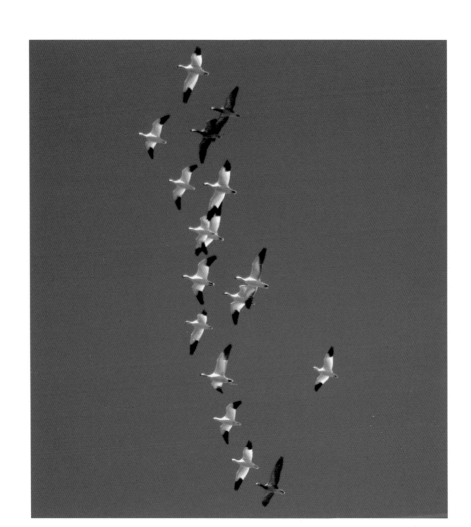

MUSKRATS

Muskrats, like most wildlife species, are always looking for new territory that is free of competition. This is especially true of young animals that may be driven from their home range by their parents when they are of breeding age. This muskrat has found a small pond to its liking and is making use of cattails and bulrush root stalks for a food supply. Underwater stems and roots of many wetland emergents are a good source of starch, like our potatoes; muskrats and beavers utilize them extensively.

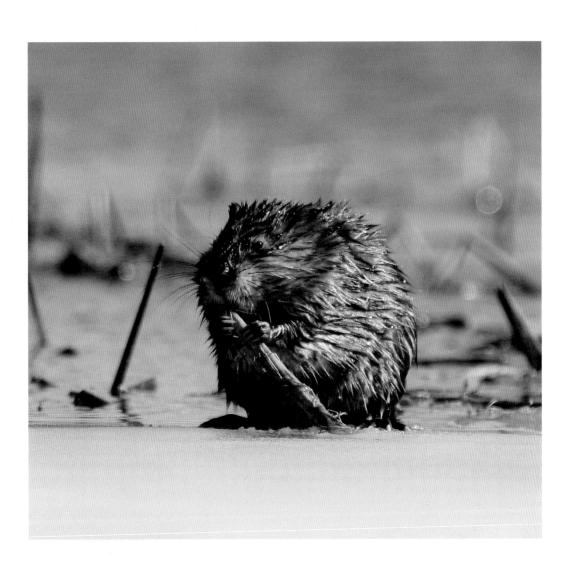

RED-WINGED BLACKBIRDS IN MIGRATION

Early spring bird migrations occur in spite of the weather. In the Midwest, red-winged blackbirds and grackles begin to head north in massive flocks during late February and early March to set up breeding territories. Temperatures are generally moderate during a spring snowstorm compared to mid-winter, yet below-freezing conditions may persist at night. Flocks may include a few dozen individuals or tens of thousands.

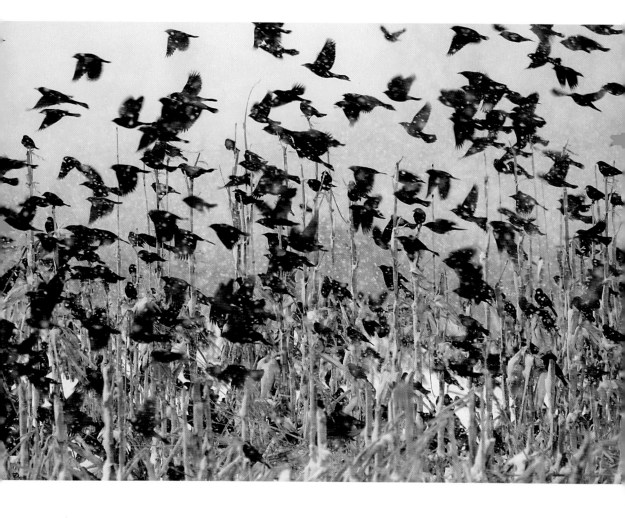

POND ICE

Pond ice may be covered with meltwater one week and three inches of new ice the next. On an afternoon walk I realized that seed dispersal continues throughout winter and found this common milkweed seed caught up in the freezing process. Turtles were supposed to be deep in the mud, but I observed one snapping turtle and a group of backswimmers swimming along the warm leeward shore where the ice is too thin for walking. I wondered if there was a shortage of dissolved oxygen in this shallow water pond.

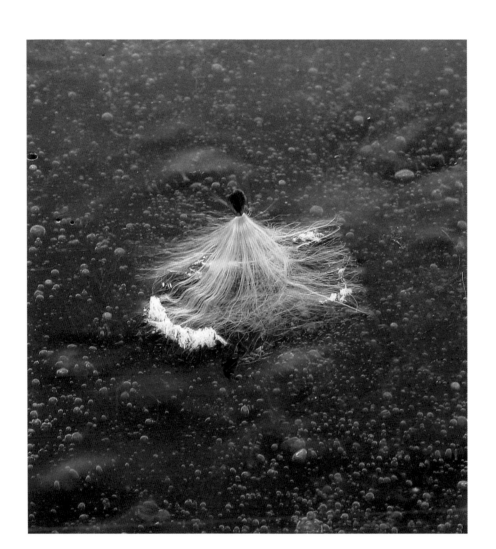

RICTAL BRISTLES

Evolution has a way of adapting a species for optimum function in its environment. One subtle but important adaptation in birds, such as this blue jay, is the presence of rictal bristles. They are small hairlike feathers at the base of the bill. It is felt that they may aid in the capture of food in flight and protect the bird's eyes from insect legs or beating wings.

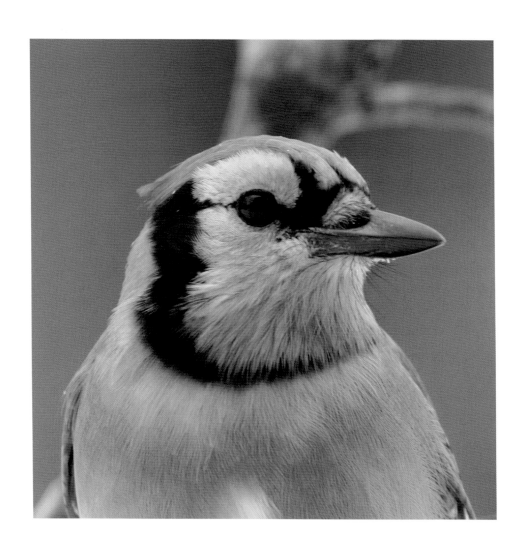

April

WARBLERS IN THE SNOW

꙳ Warblers, such as this yellow-rumped warbler, are basically insectivorous. During a late spring snow, we observed them feeding on the snow although there was no evidence of flying insects. In the woods they appeared to seek out open spots where the wet snow had melted. They would often approach within a yard of my feet when I stood still. We need to remember that bad weather can create opportunities for unique encounters with wildlife.

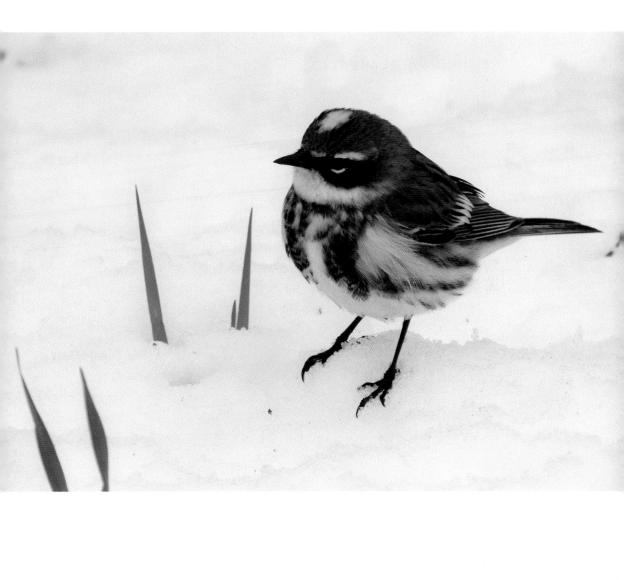

VIRGINIA BLUEBELLS

Virginia bluebells are found in moist upland woods and on forested floodplains. They normally bloom from mid-April through mid-May in the upper Midwest. In an unseasonably warm spring, flowering may begin three weeks to a month ahead of their normal schedule. I have seen their flowers covered with wet snow in late April. Here they are mixed with ostrich ferns. They make excellent yard flowers as they die back to the ground in late May and do not appear again until the following year.

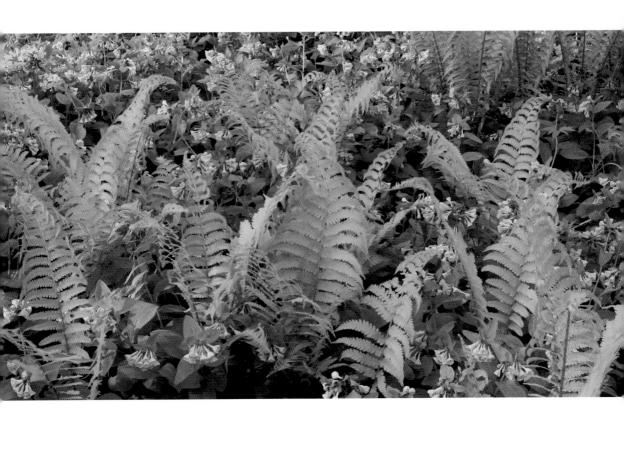

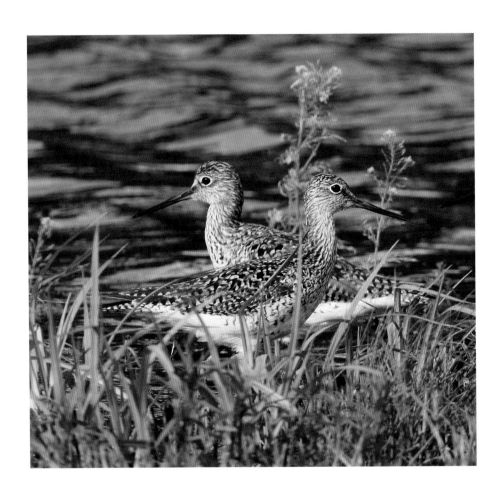

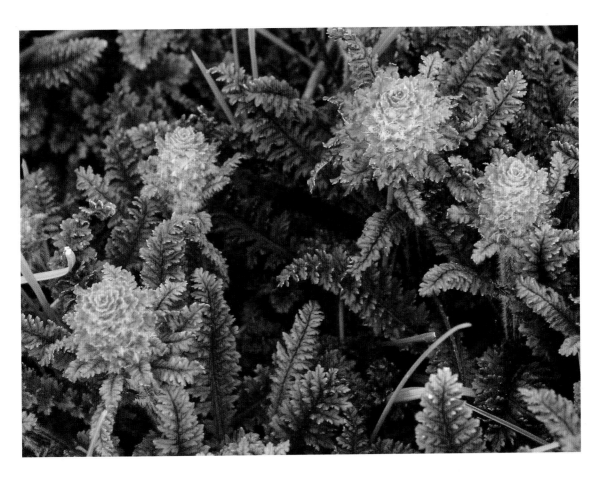

SORA RAILS

Sora rails are small, sly, secretive, and often overlooked, which must be why they are sometimes called mouse birds. If they stand motionless behind a small stand of dried rushes, they are virtually invisible. While soras creep around in wet meadows and marshes, their cousins, yellow rails, appear to favor the dryer upland grasslands. We see soras most often in spring feeding on the edges of ponds. In fall migration, groups may be present feeding in open marshes, while single birds can be flushed in wet meadows.

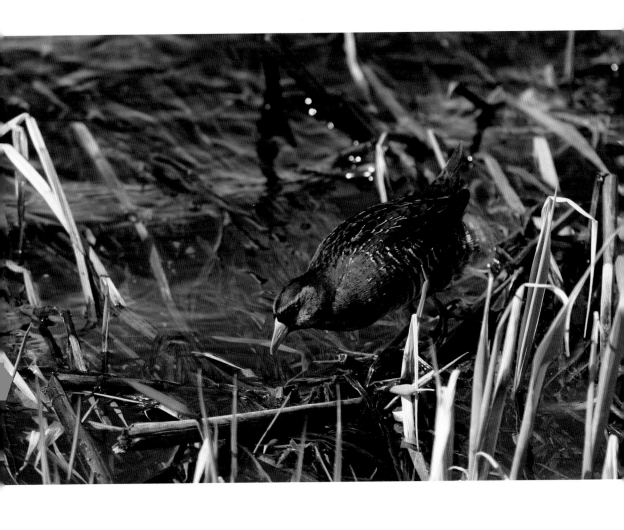

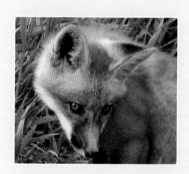

CURIOSITY

꧁ Curiosity is a very important aspect of behavior in the growth and development of most animal species. Critters, humans included, use their senses to explore and learn about the world. We often think that visual observation is the most important, but it is generally combined with the senses of touch, smell, and hearing. These young red foxes will ultimately depend on all their senses for survival.

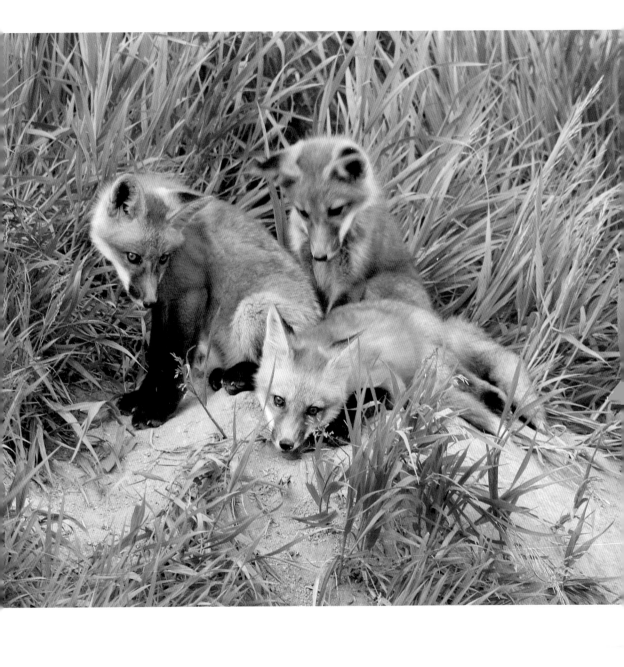

JACK-IN-THE-PULPIT

Most of us have seen Jack-in-the-pulpits at one time or another in spring woodlands. It is a monocot (that is, it has one seed leaf) and is in the Arum family with sweet flag and green dragon. The shape of the flower is termed bilaterally symmetrical. They appear to grow the largest in moist woodland ravines and seem immune to deer browsing. Jack-in-the-pulpits are very easy to grow from the red fruits that form in the fall. They should be planted immediately and will come up the following spring. The first year three small leaflets form; in subsequent years the plant will grow larger and finally produce its distinctive flower.

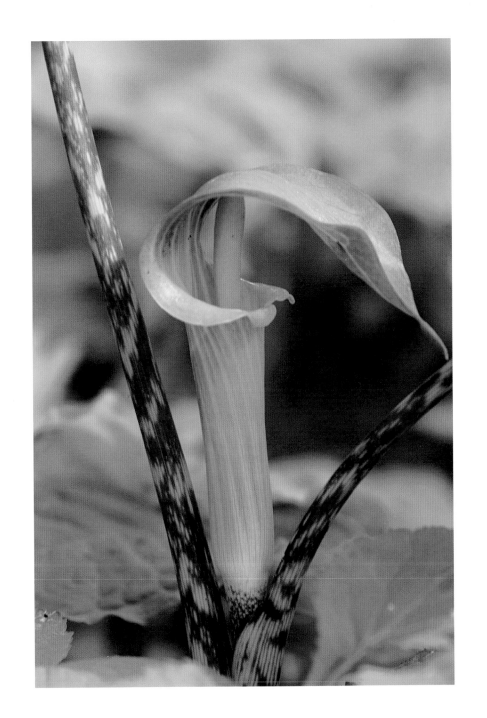

NEW LEAVES

After seeing bare branches on deciduous trees for six or seven months, new green leaves are a revelation. It is as if the dead have come back to life. New leaves are usually yellow green, cyan, or even reddish and somewhat transparent compared to the deep dark green that persists throughout the summer. Each tree seems to have its time. Some trees, such as willows, burst forth in April, while mulberries in mid-May are still minute as if waiting for summer. Black walnut leaves are compound and appear as tiny fans against the blue. One of nature's great sounds is that of leaves fluttering in the breeze. Just the thought of it makes us feel cooler.

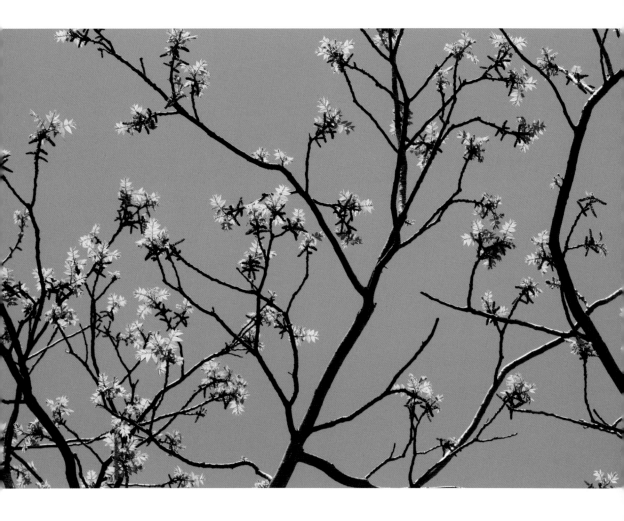

PRAIRIE SPIDERWORTS

Some flowers are tough and last for weeks, others for only a single day or, as in the case of prairie spiderworts, for just a few hours. As the morning light level increases, spiderworts open and then begin to close by midday. On cloudy days, however, they often remain open until late afternoon. Whether pollination occurs often determines how long a flower stays in bloom, which is influenced by light, heat, and insect activity.

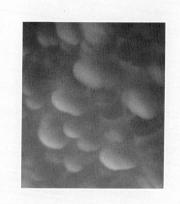

RUDDY DUCKS

Ruddy ducks are small divers and the only common continental member of a group called stiff-tailed ducks. They utilize the heavy vegetation for breeding habitat. Up-and-down head bobbing is a common courtship display during the breeding season in many species of waterfowl. In the ruddy duck it emphasizes their distinctive sky-blue bill.

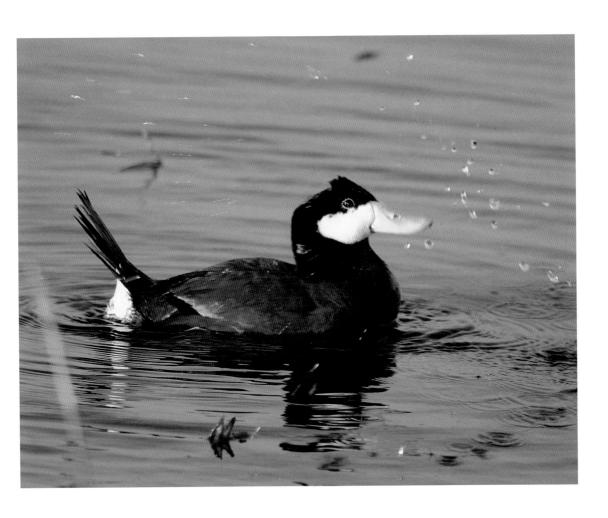

MAIDENHAIR FERN

Ferns attract our attention with their shape or lush verdant color in a woodland habitat. Generally they favor cool, moist environments on a shaded slope or on the north side of a dwelling. These areas provide protection from warm drying winds that can cause their demise during a very dry period of weather. While ferns are vascular plants, they do not produce seed and have no flowers; instead, spores are released. In somewhat oversimplified terms, the spores produce a gametophyte and after a series of changes it turns into a sporophyte, which is the typical fern. Here we see a leaflet or pinnae of a maidenhair fern frond.

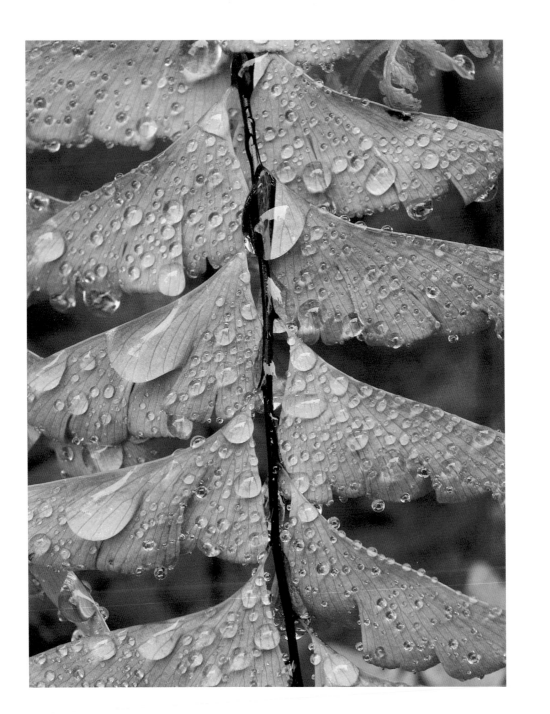

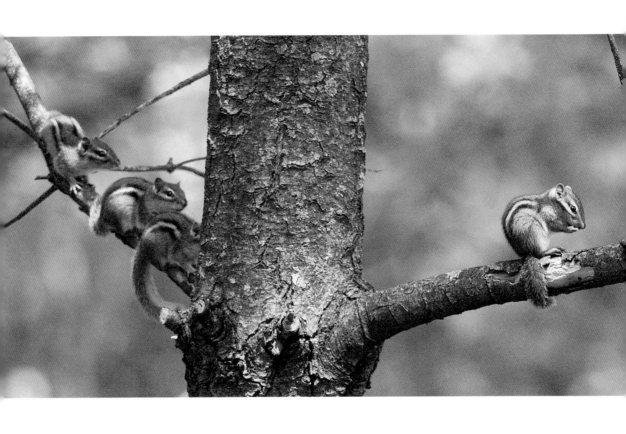

MAMMATUS CLOUDS

The process of cloud formation often begins in mid-day as temperatures rise. First, there are puffy cumulus clouds; these, however, can grow into cumulonimbus clouds or towering thunderheads. In the distance they may appear in the recognizable shape of an anvil. Warm moist updrafts feed these cloud giants until the air becomes heavily saturated and loses its momentum. It then begins to sink back to the earth. The process is somewhat complicated, with a complex exchange of heat and energy taking place. The subsiding air may form cotton ball-like mammatus clouds as the downdrafts encounter gently rising air just below. Mammatus clouds may or may not indicate severe weather; they can occur before or following the downpour of the storm.

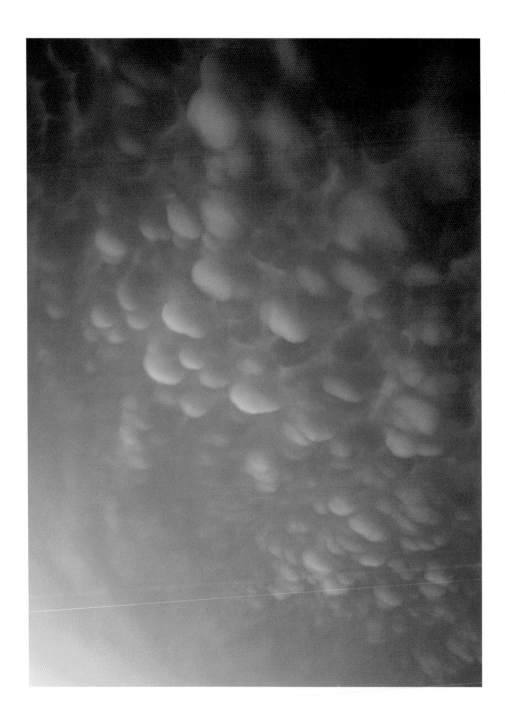

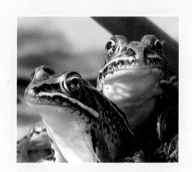

HICKORY HAIRSTREAK

Hot weather is favored by insects such as the hickory hairstreak, a small butterfly about the size of a dime. Butterflies are important pollinators of many flowers. Most species respond to changing weather conditions; thus, they vary in abundance from one year to the next. The strong wind currents of weather fronts or storms may help species migrate from one part of the country to another.

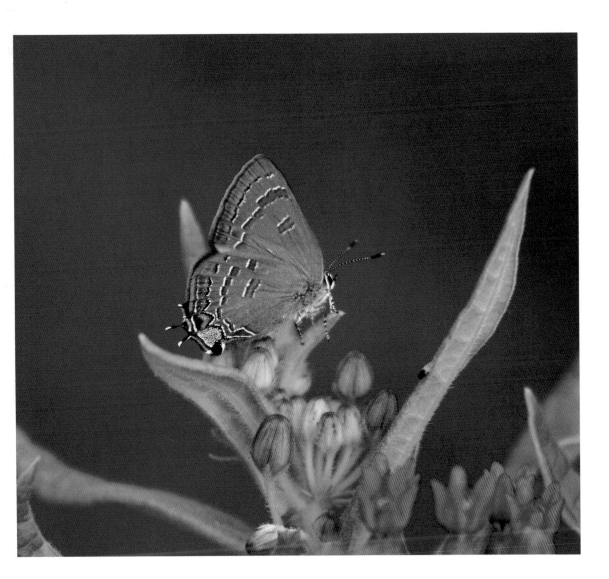

PRAIRIE COMPANIONS

There is scarcely elbowroom in mid-summer tallgrass prairie. A host of species compete for space to grow; however, they also give each other physical support. Competition below the soil surface for root space is not readily apparent, but likely fierce. It keeps individual plants in line and prevents them from becoming rank and unruly. Competition coupled with diversity gives the community stability; if you are out of your element soil- or water-wise, you are out of the picture. Tall blazing-star and prairie cinquefoil dominate the front row, while purple prairie clover, pale purple coneflower, stiff goldenrod, and showy tick-trefoil are apparent in the background.

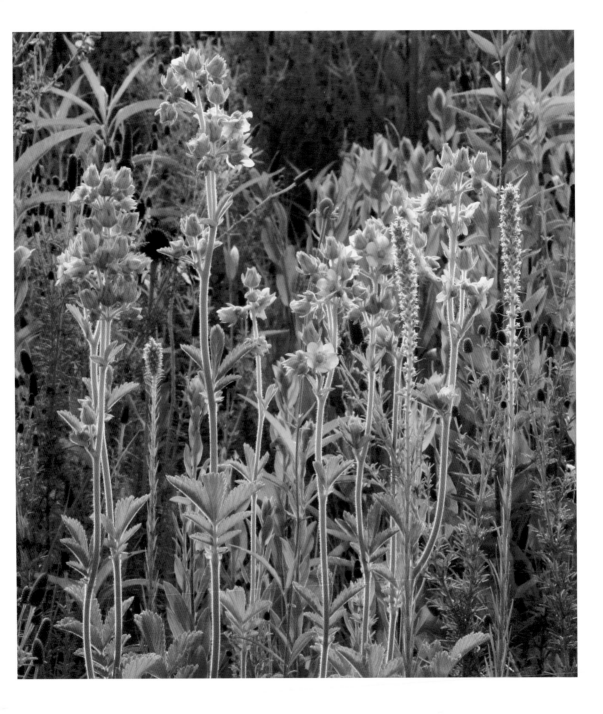

LEOPARD FROGS

Small ponds with emergent vegetation such as water lilies provide good habitat for amphibians such as leopard frogs. They are part of the food chain feeding on a wide variety of aquatic insects, butterflies, worms, and even other small frogs or birds, when given the opportunity. In turn they provide food for fish, turtles, and large birds such as herons and egrets. These pictured juveniles may be huddled together for protection—many eyes have a better chance of detecting a predator.

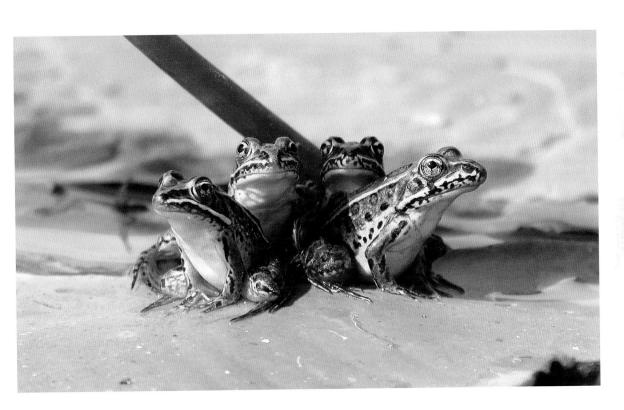

DESIGN

Design is an arrangement that leads us to believe there is order in chaos, but in a way it may not necessarily follow the rules we think are part of good design. The detail in the wing of a common butterfly, in this case the underside of a red-spotted purple, has both consistency in its repeating pattern and randomness in its arrangement of its irregular shapes. It is a mystery how this all came about, but it must serve the species well. The world is full of intricate details that are part of nature's grand design.

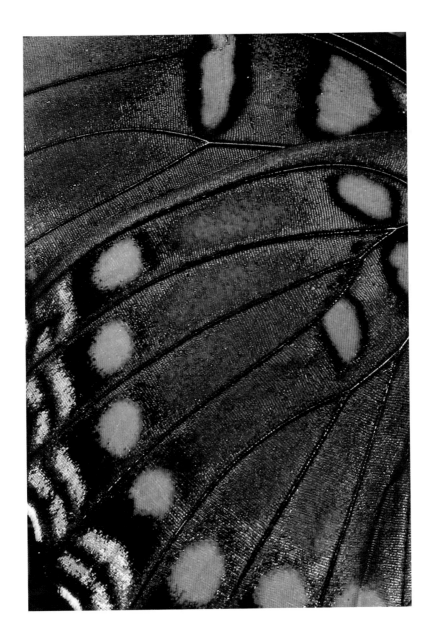

BLUE-WINGED TEAL

Shallow-water marshes provide not only habitat for breeding ducks such as blue-winged teal, but also a fall food supply that includes plants such as water smartweed. When there is adequate rainfall, these wetlands provide places to raise young birds. Generally a drying-out period is required to aid in the germination of species like smartweed. As a result many birds that use wetlands move about each year to find suitable water conditions for nesting and raising their young. The mystery remains: how do they know which direction to go?

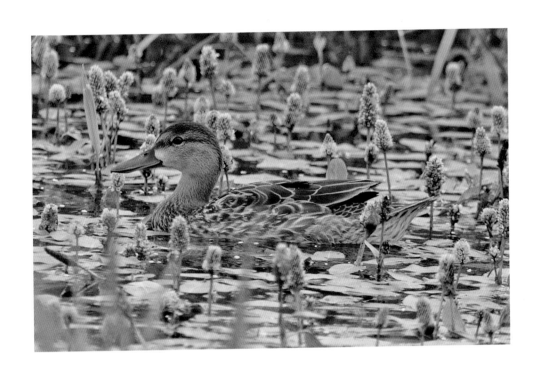

August

FLOWERING SPURGE AND ANTS

Flowering spurge is a late summer flower that is still quite common along country roads. It appears to be quite resistant to herbicides and thus has survived in areas where roadside spraying has otherwise eliminated most other prairie forbs. Seeds in a three-lobed seed capsule are somewhat difficult to collect as the capsules explode when mature. A common field ant on this flower is apparently drinking nectar and pollinating the flower.

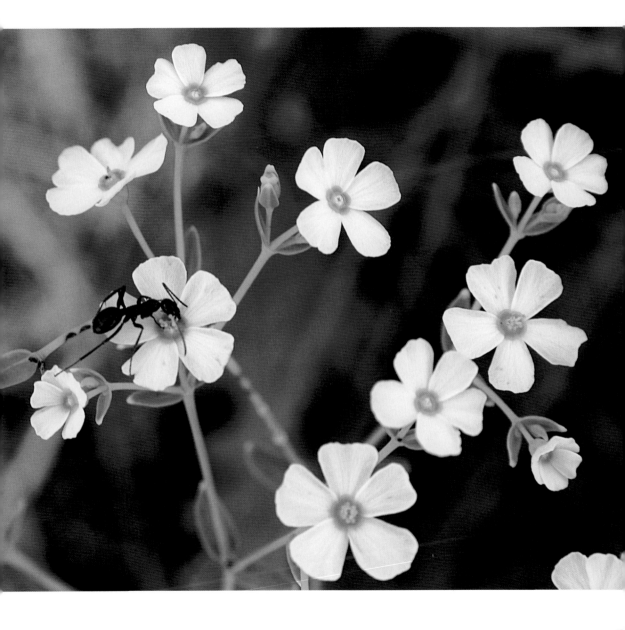

NORTHERN FLICKERS

Northern flickers are common woodpeckers where there are trees for nesting. They do not seem to require high-quality forest and may nest along prairie streams, in old farmsteads, and in cities. They feed their young by regurgitation and can be found foraging in both woodland and open prairie habitats. We have also seen them competing with starlings for nest cavities. Our eastern U.S. form was known as the yellow-shafted flicker because of its yellow-shafted wing primaries and tail feathers, but it is known to interbreed with the red-shafted and gilded flickers in the West and Southwest. Note the black mustache indicating an adult male and young.

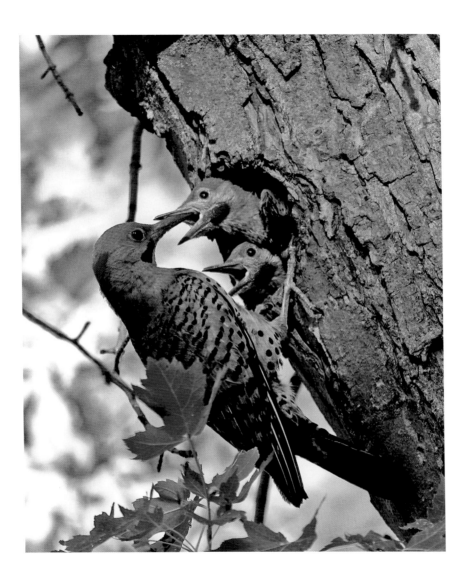

BLACK SWALLOWTAIL

One of the most enjoyable aspects of nature observation is viewing a common species in a new way. In this case we are looking at the underside of a black swallowtail butterfly, which is feeding on Culver's root, a native prairie plant, with the sunlight coming through its semi-translucent wings. Butterflies are marvelous creatures with tissue paper–thin wings, bodies that are as light as a feather, and erratic flight, yet they can easily navigate cross-country in spite of moderate winds in search of host plants or nectar sources.

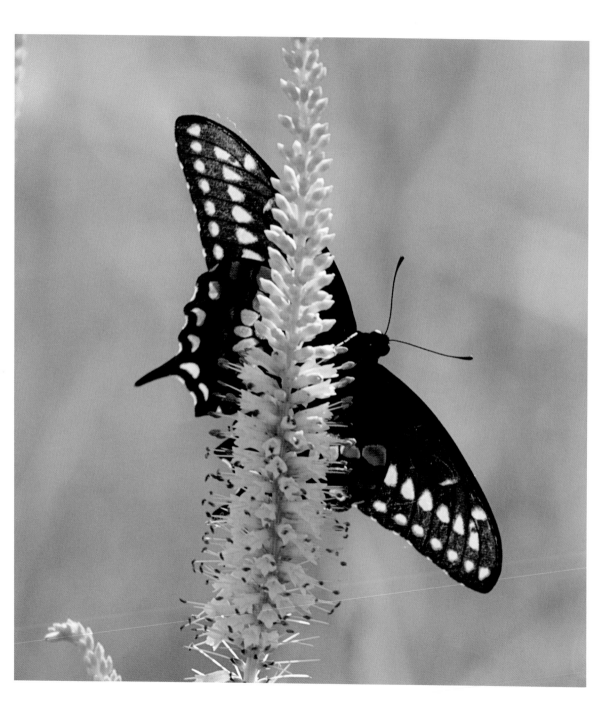

AMERICAN GOLDFINCH NESTING

John Muir once stated that everything is hitched to everything else in the universe. There are many connections we can see. Goldfinches nest in small trees, shrubs, thistles, or other tall plants generally in an open landscape. Here we see a female goldfinch incubating her eggs in a nest attached to a compass plant in the open prairie. The lining of the nest is often thistle down, but in this case corn silks have been used. The nesting cycle of American goldfinches normally begins after the first of August and may extend into mid-September.

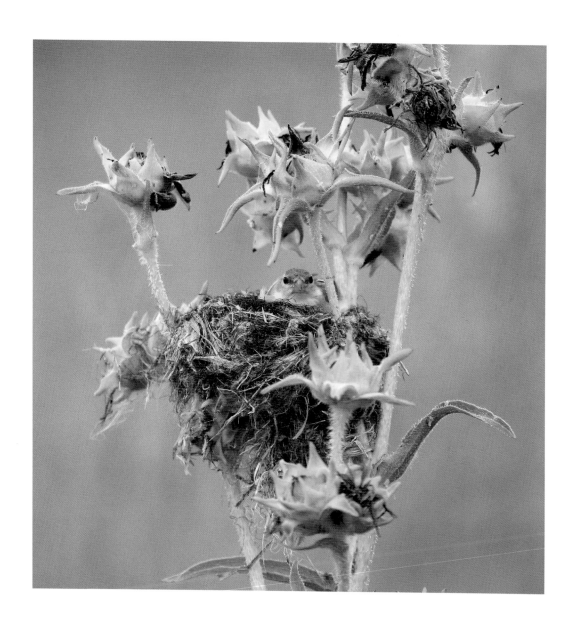

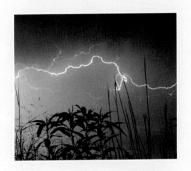

September

MARES' TAILS

Thin gossamer cirrus clouds generally indicate a change in weather and often precede fronts that move from west to east. They form about five miles or more above the earth and are composed of ice crystals. They are commonly called mares' tails due to their shape and form, which changes constantly due to strong upper level winds or wind sheer. A curtain of snow or ice crystals often precipitate from them, but it soon evaporates. Late in the day they can produce spectacular sunsets.

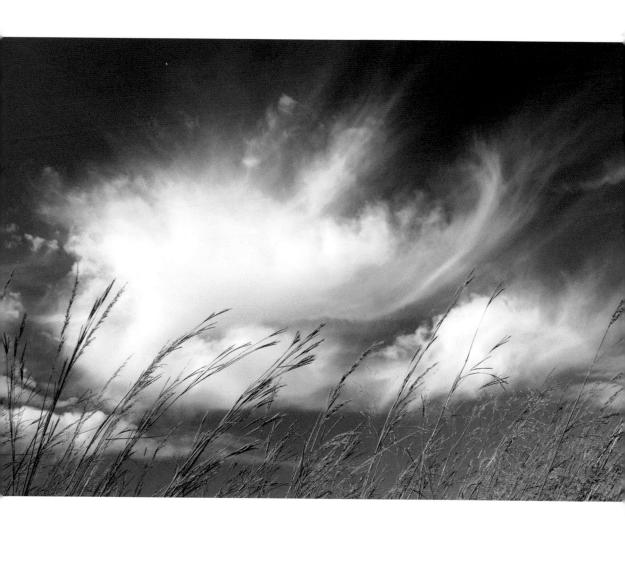

CLOUD-TO-CLOUD LIGHTNING

All of us have had the opportunity to observe lightning in daylight and in darkness, in the distance and likely when it was too close for comfort. Lightning is an immense charge of static electricity between a positively charged cloud and the negatively charged earth's surface. Lightning within clouds or between clouds is actually more common than cloud-to-ground lightning. If it occurs within a single cloud, it is called intracloud lightning. If it occurs between clouds, it is intercloud lightning. This effect is also sometimes called sheet lightning since it may not be possible to see the actual lightning streak.

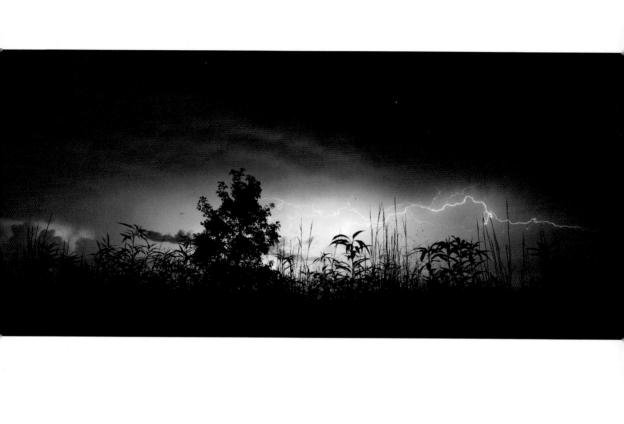

A BIRD IN THE BUSH

The old proverb, a bird in the hand is worth two in the bush, urges us to be satisfied with what we have and not yearn for more. When it comes to watching birds, a bird in the hand is not very likely and even two or more in the bush may be difficult to identify. Migrating warblers, such as the common yellowthroat, are heading south to keep up with their insectivorous food supply. On an early morning foray they may be just one of a host of small birds that we can find creeping through heavy undergrowth. Whether it is on the edge of woods or in tallgrass prairie, a glimpse is often all we get. Sometimes it is hard to be satisfied.

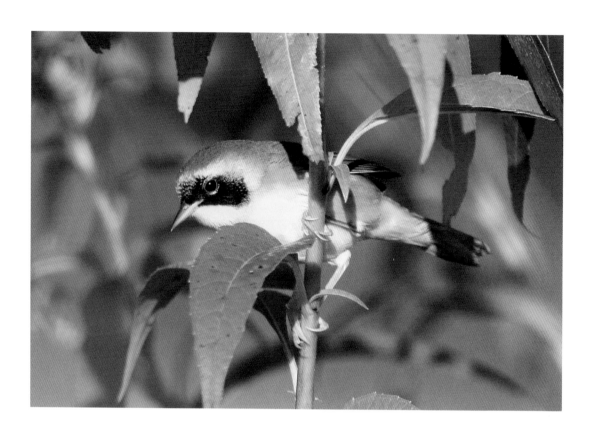

MONARCH MIGRATION

Monarchs in autumn migration frequently gather to roost in late afternoon. After feeding on late summer flowers such as goldenrods, they begin to float in like autumn leaves. Roost sites generally tend to be out of the wind on the leeward side of a woodland. New arrivals often elicit a response from the group as they settle in. A wing fluttering action often travels across the group; however, this may cause them to momentarily take flight.

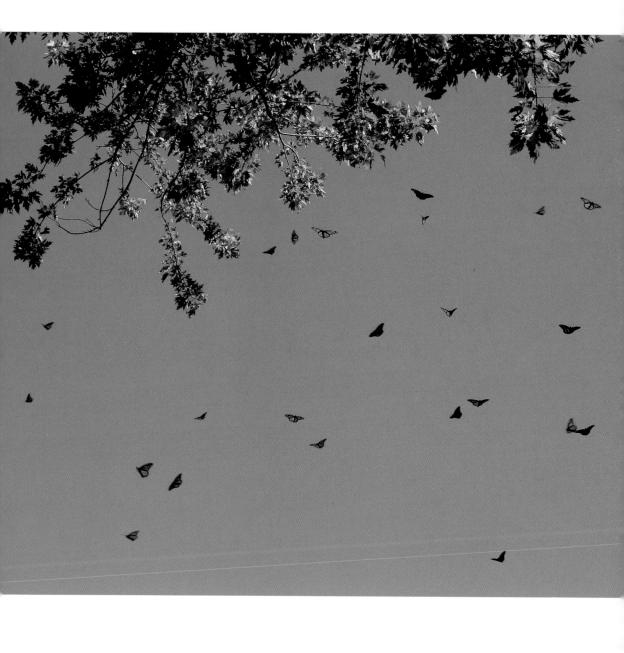

MORNING DEW

Clear skies, little or no wind, and falling temperatures in early autumn create perfect conditions for heavy morning dew on the prairie. Species such as Indian grass may succumb to the weight of the water. Both birds and mammals often try to avoid the tall wet vegetation and move into open areas, mowed lanes, and grazed pastures. Without waterproof pants and a jacket, a person easily becomes soaked to the waist and chilled. Yet it is just this appeal that urges one to go out, look, and listen.

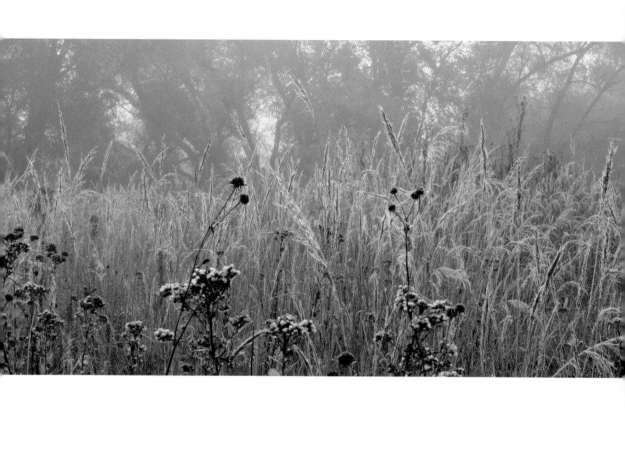

October

DOWNY GENTIANS

Late fall flowers include some asters and gentians. One of the last gentians to be in full bloom is the downy with flowers that are an intense blue. They grow on moderately dry prairie hillsides and, at only about twelve inches in height, are dwarfed by tall grasses and sunflowers. Like other gentians the downy's seeds are thin, wafer-like, and likely run several million to the pound. Garden mums and pansies are no match for discovering a downy gentian in full bloom in the autumn prairie.

BIGTOOTH ASPEN

If you are in the timber industry, you think of aspens as pulpwood for the production of paper. A naturalist, on the other hand, sees them as an early stage in forest succession, often growing up after a clear-cut, windstorm, or forest fire. Both quaking and bigtooth aspen belong to the cottonwood family. They grow up quickly but don't have the long lifespan of oaks and maples. Generally, quaking aspens prefer moist sites while bigtooth aspens grow on dryer uplands. Both species are favorites for beavers and utilized for food and the construction of dams and lodges. Ruffed grouse feed on the leaves in summer, the flower buds in winter, and the catkins in spring.

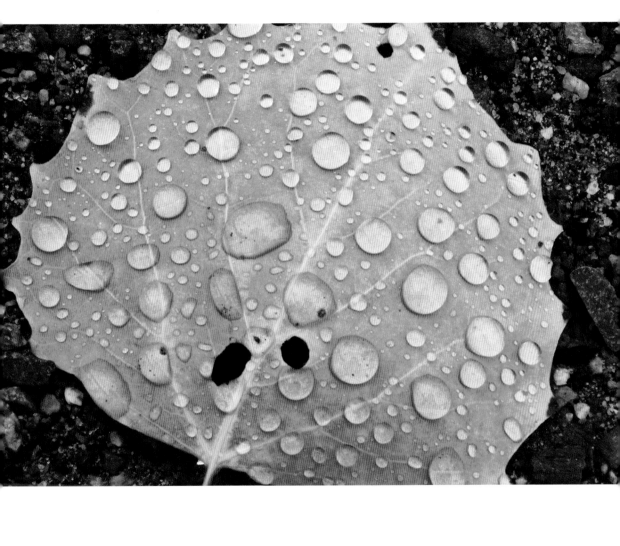

INTIMATE BEHAVIOR

Intimate animal behavior reminds us of the strong bond between mothers and their young. White-tailed deer often greet each other by touching noses, or in the case of this doe and her five- or six-month-old fawn, she may groom its coat. Come spring, the fawn's presence will be tolerated less and less, and it will be forced to make a life for itself. Be alert for unique behavior; when observing make little noise and avoid all movement if possible.

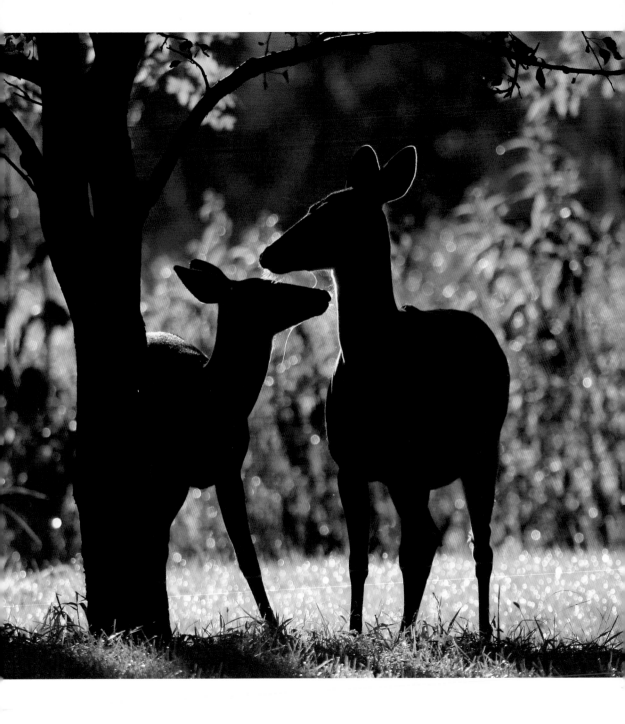

PRAIRIE HORIZON

What value is there in an unobstructed prairie skyline? We witness the change as new utility poles, cell phone towers, and now wind generators (turbines) are constructed. What is a view really worth? Is there a way to measure its intrinsic value? To most of our society, this is a question that is not even being asked.

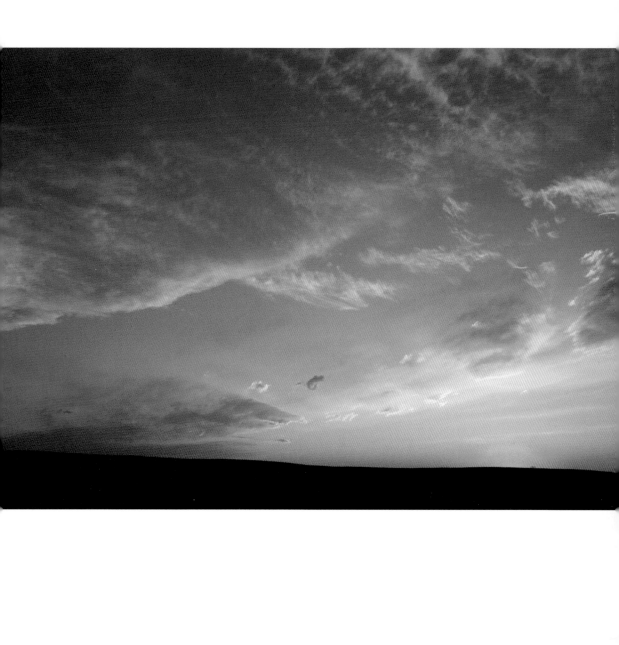

ORANGE-CROWNED WARBLER

🖋 Warblers in fall migration, such as this orange-crowned warbler, are normally found foraging in trees. This bird found the prairie a prime feeding area. Mature seed heads of species such as rigid goldenrod may contain lurking insects or overwintering insect larvae. Late migrants such as bluebirds, kinglets, or sparrows are often found in sheltered areas, as they move just ahead of cold fronts on raw windy days.

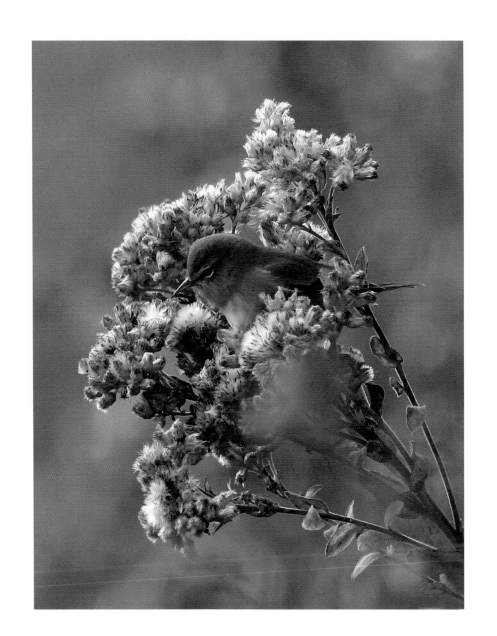

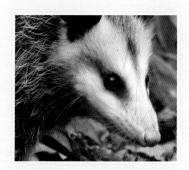

November

TUNDRA SWANS

The Mississippi River is unprecedented as a migration corridor for birds of all kinds, but especially for waterfowl. Shallow backwater sloughs, protected coves, and tree-covered islands provide resting and feeding habitat. Tundra swans highlight mid-November on their journey south and east toward the eastern seaboard. Here we see them moving about in mid-morning along with Canada geese and thousands of ducks. The distant river bluffs of Wisconsin provide an impressive backdrop.

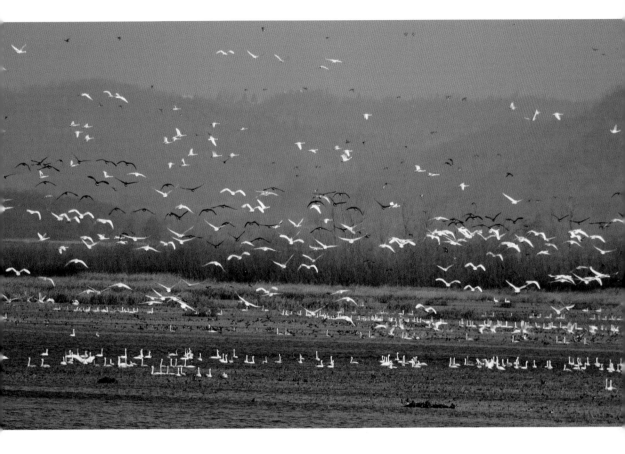

JUVENILE RED-TAILED HAWK

Birds of prey attract our attention. Eagles are large and majestic, falcons are among the fastest flying birds, and hawks seem to soar effortlessly on thermals as they search for prey. As predators in the food chain, they play an important role in keeping rodent populations in check. This juvenile red-tailed hawk lacked the wariness of mature adult birds but had learned some of the skills needed to survive on its own. Its first year will likely be the most difficult.

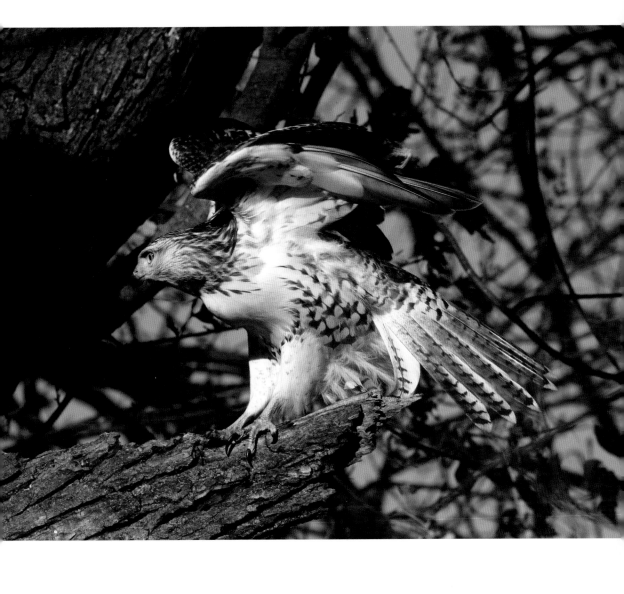

WILD PRAIRIE LIGHT

⁊ A change in the weather that begins either early or late in the day sometimes means a dramatic lighting effect. In this case it is caused by the stark contrast between a sunlit landscape in the foreground and the dark clouds of an incoming storm front, which lack direct light. In his writings about the North Country, Sigurd Olson called this Ross Light. Although others may have their special names for this phenomenon, no matter what you call it, a place we know well can be momentarily transformed.

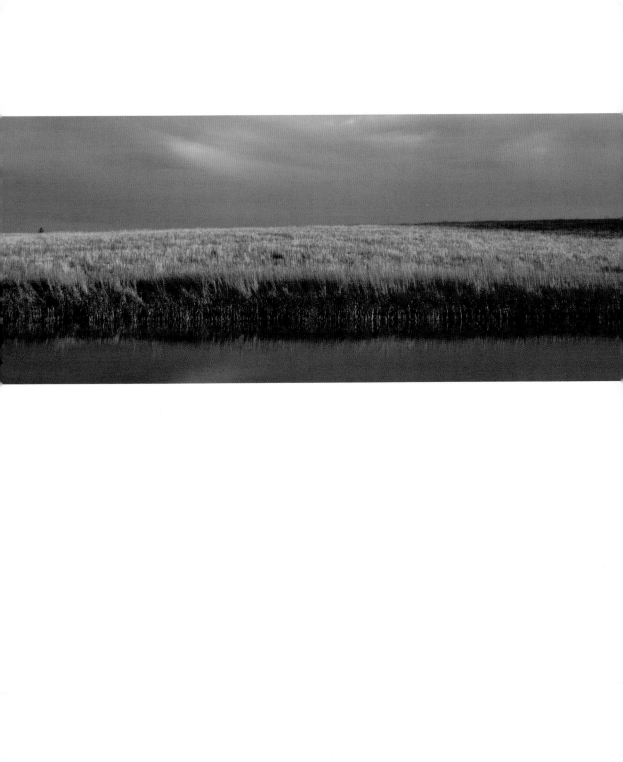

OPOSSUM

Opossums may be our most misunderstood mammals. They are our only native marsupials—mammals that raise their young in a pouch like the kangaroo. Like raccoons they are omnivores, eating fruits, insects, or small animals; however, one of their main food sources is carrion. As their name implies, they play possum (when threatened) by faking death, but they do not hang from branches with their hairless prehensile tails. Other interesting features of opossums include the opposable thumbs on their rear feet.

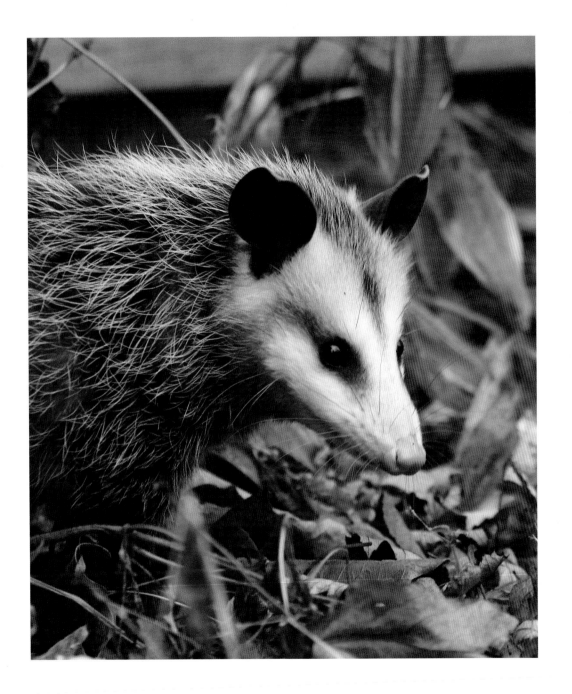

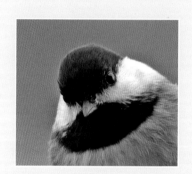

December

BADGER

Many of you have likely never seen a badger. While they are relatively common in the farmlands and grasslands of the Great Plains, they do not go about their business in a manner that makes them particularly conspicuous. They are active primarily at night and otherwise spend most of the daylight hours underground. We often hear of them as being fierce, but I know of no instance where one has attacked a person. Their first reaction at being encountered is to try to scare off the intruder. If that fails, they will either disappear underground or simply run off as fast as possible. Watch roadsides and if you are lucky you may just see a badger emerging from its underground burrow. As with most wildlife observations, patience and persistence have their rewards.

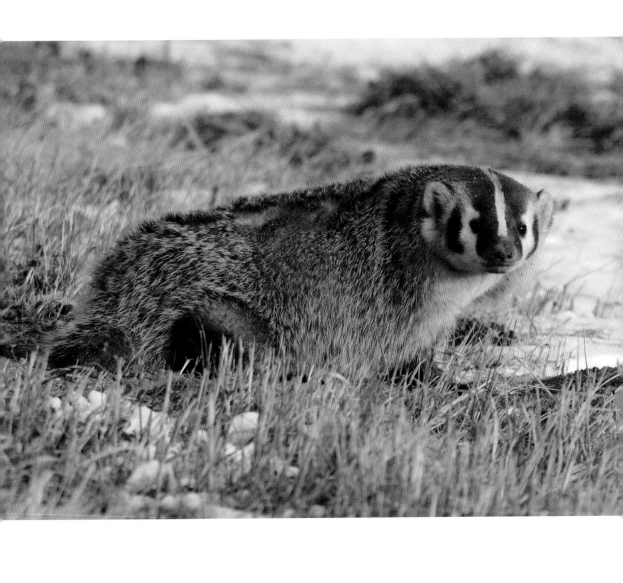

AMERICAN SYCAMORES

Old American sycamores are majestic trees in winter when the colors of the trunk and branches decorate the landscape. The white upper bark appears as a smooth tight skin mottled with brown and black splotches. They grow best on bottomlands in deep rich soils where their feet are wet. On floodplains old trees can be massive, more than a hundred feet in height with a diameter at the base of nearly fifteen feet. The spreading branches make the sycamore a wonderful yard tree; however, one must be prepared to deal with their huge maple-like leaves each autumn.

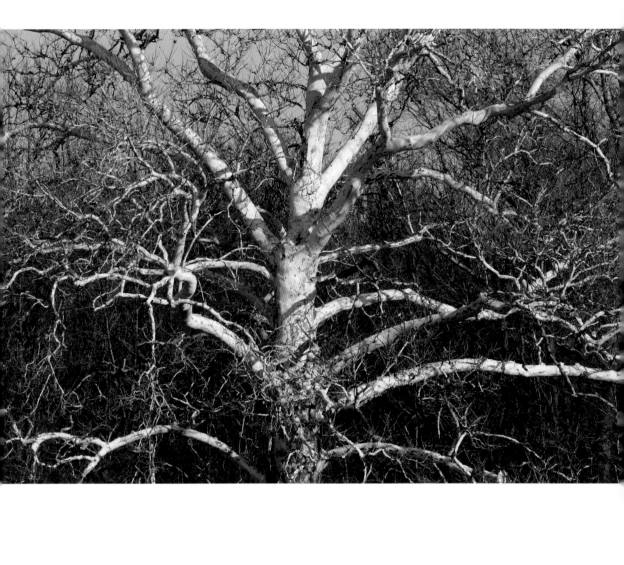

TRUMPETER SWANS

Trumpeter swans are our largest waterfowl with a wingspan of more than six feet and a weight of up to twenty-eight pounds. These birds are a wildlife management success story: a rough count in the mid-1930s was under 100 birds, while the nationwide number today is near 40,000. To see trumpeter swans in flight, on the ice, or in a snow-covered field is always a special experience.

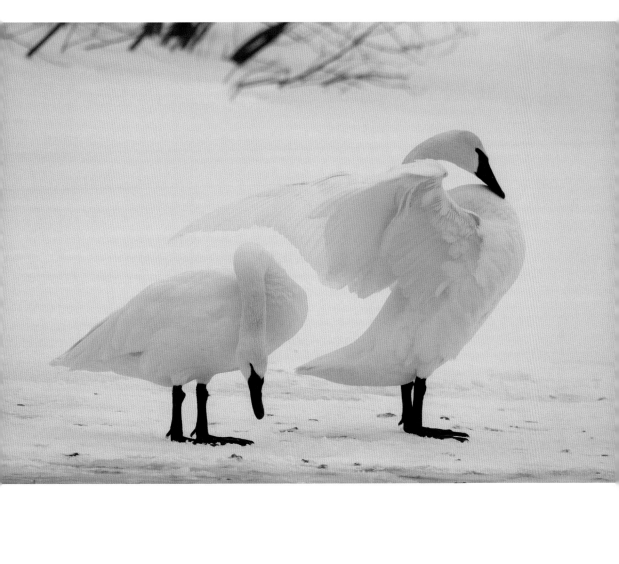

BLACK-CAPPED CHICKADEE

Black-capped chickadees belong to the family Paridae, along with the tufted titmouse. We know them as minute in size and quick as a wink. The most amazing aspect of this bird is its range, which extends over much of North America well up into Alaska. Given its size, it is a miracle that it can survive winter in the frozen north. Try holding sunflower seeds, and some of these birds will feed from your hand.

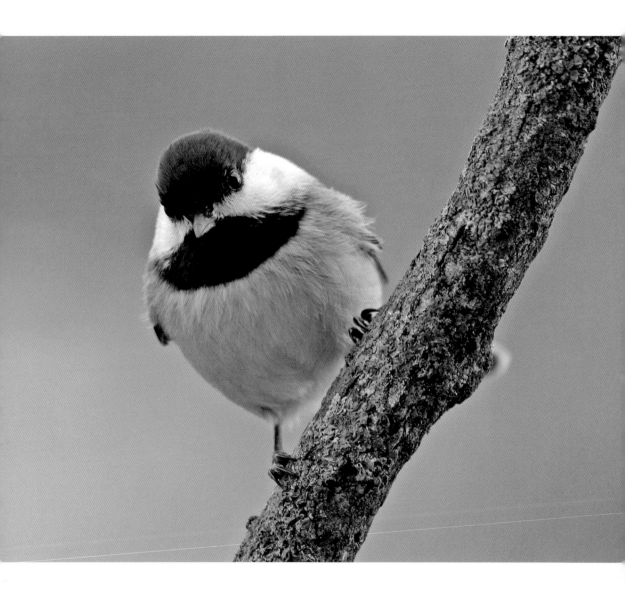

PHOTOGRAPHER'S NOTE

I used six-, ten- and twelve-megapixel Canon cameras to take the photos. I used an 18-55 mm lens primarily for landscapes and close-ups and a 100-400 mm lens for birds, mammals, and often insects such as butterflies. Since most lenses are now vibration-stabilized in some manner, I rarely had to use a tripod. Occasionally I added a 12 mm extension tube to shorten the focusing distance of both lenses. My motto is "keep it simple."

White-tailed Deer, January 9, 2005
Bald Eagles, January 17, 2010
Evening Twilight, January 19, 2005
Mallards, January 4, 2009
Ice Dancer, January 2, 2011
Cardinals, February 13, 2005
Drifting Snow, January 17, 2008
Snow Buntings, February 6, 2011
Rime Ice, February 1, 2009
Cedar Waxwings, March 11, 2007
Snow Geese, March 11, 2012

Muskrats, March 20, 2010

Red-winged Blackbirds in Migration, March 27, 2004

Milkweed Seed Dispersal, March 12, 2006

Rictal Bristles, March 7, 2010

Warblers in the Snow, May 3, 2013

Virginia Bluebells, April 1, 2012

Greater Yellowlegs, April 29, 2012

Wood Betony, April 18, 2010

Mouse Birds, April 23, 2006

Curiosity, May 23, 2010

Jack-in-the-pulpit, May 15, 2005

New Leaves, May 18, 2008

Prairie Spiderworts, May 20, 2012

Ruddy Ducks, June 14, 2004

Maidenhair Fern, June 14, 2009

Chipmunks, June 5, 2011

Mammatus Clouds, June 29, 2008

Hickory Hairstreak, July 17, 2005

Prairie Companions, July 8, 2007

Leopard Frogs, July 15, 2012

Design, July 30, 2006

Blue-winged Teal, July 26, 2008

Flowering Spurge and Ants, August 16, 2004

Northern Flickers, August 7, 2005

Black Swallowtail, August 3, 2008

American Goldfinch Nesting, August 15, 2006

Mares' Tails, September 5, 2010

Cloud-to-Cloud Lightning, September 10, 2006

A Bird in the Bush, September 11, 2011

Monarch Migration, September 10, 2010

Morning Dew, September 26, 2010

Downy Gentians, October 11, 2009

Bigtooth Aspen, September 19, 2009

Intimate Behavior, October 12, 2008

Prairie Horizon, October 28, 2007

Orange-crowned Warbler, October 15, 2006

Tundra Swans, November 23, 2008

Juvenile Red-tailed Hawk, November 7, 2010

Wild Prairie Light, November 14, 2010

Opossum, November 9, 2008

Badger, December 20, 2009

American Sycamores, December 18, 2011

Trumpeter Swans, December 19, 2010

Black-capped Chickadee, December 27, 2004

OTHER BUR OAK BOOKS OF INTEREST

Birds of an Iowa Dooryard
Althea R. Sherman

The Butterflies of Iowa
Dennis W. Schlicht, John C. Downey, and Jeffrey Nekola

A Country So Full of Game: The Story of Wildlife in Iowa
James J. Dinsmore

Deep Nature: Photographs from Iowa
Linda Scarth and Robert Scarth

The Elemental Prairie: Sixty Tallgrass Plants
George Olson and John Madson

The Emerald Horizon: The History of Nature in Iowa
Cornelia F. Mutel

Enchanted by Prairie
Bill Witt and Osha Gray Davidson

Prairies, Forests, and Wetlands: The Restoration of Natural Landscape Communities in Iowa
Janette R. Thompson

A Practical Guide to Prairie Reconstruction
Carl Kurtz

Prairie: A North American Guide
Suzanne Winckler

The Raptors of Iowa
Paintings by James F. Landenberger, Essays by Dean M. Roosa, Jon W. Stravers, Bruce Ehresman, and Rich Patterson

Restoring the Tallgrass Prairie: An Illustrated Manual for Iowa and the Upper Midwest
Shirley Shirley

Stories from under the Sky
John Madson

Take the Next Exit: New Views of the Iowa Landscape
Robert F. Sayre

Wildflowers and Other Plants of Iowa Wetlands
Sylvan T. Runkel and Dean M. Roosa

Wildflowers of the Tallgrass Prairie: The Upper Midwest
Sylvan T. Runkel and Dean M. Roosa

ELY PUBLIC LIBRARY
P.O. Box 249
1595 Dows St.
Ely, IA 52227